Distinctly American

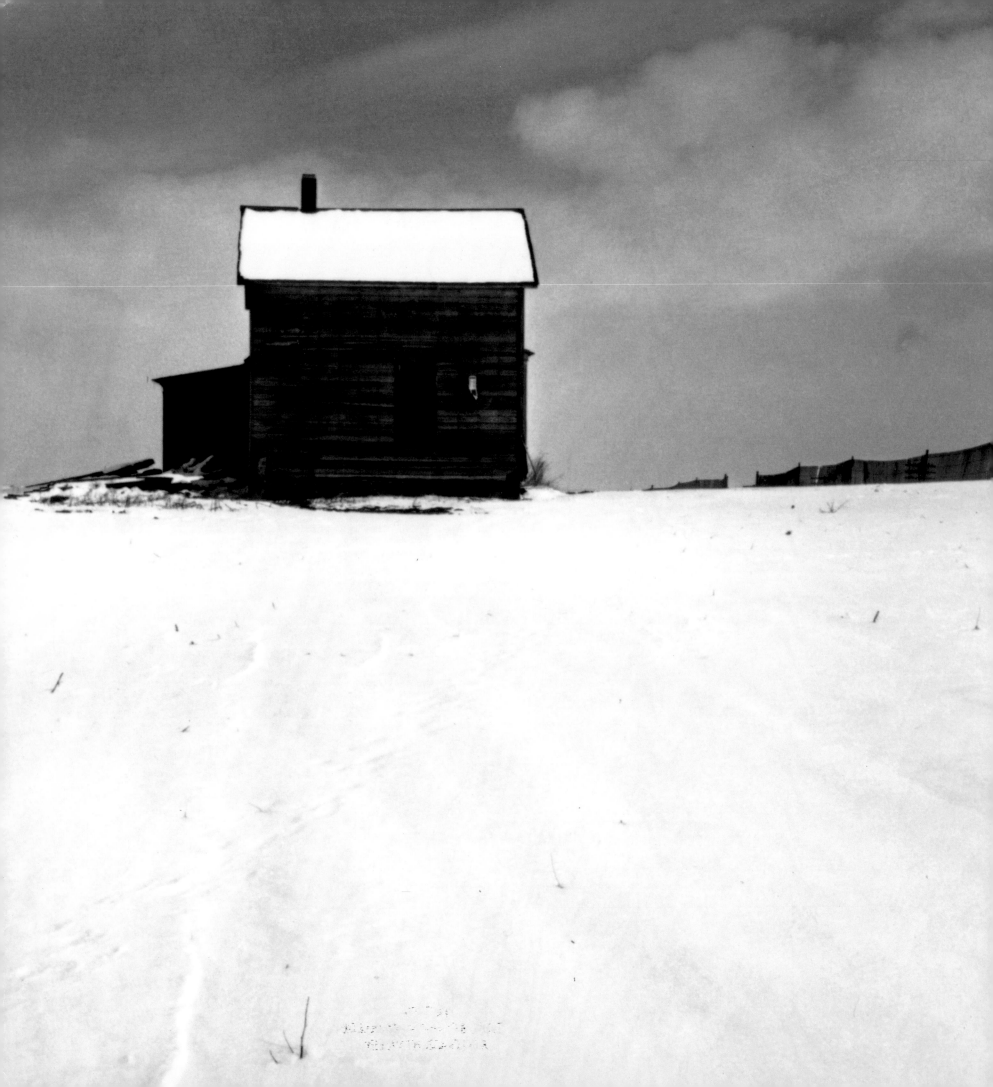

Wright Morris: American Photographer

Let me try and explain. From things about to disappear I turn away in time.
To watch them out of sight, no, I can't do it.
Samuel Beckett, Epigraph to *God's Country and My People*

Alan Trachtenberg

At first Wright Morris's photographs seem full of things and empty of people. Absence draws us in until we realize that what is missing has a kind of presence, that invisible inhabitants of his pictures make themselves felt in objects of daily life, in marks of use and wear and desire. The things usually belong to rural and small-town life—structures such as houses, churches, town halls, silos and grain elevators with cryptic inscriptions, barber shops with their mirrors and shampoo sinks, beds and dressers, tables, flatware, tools, pictures on walls. These are the things and places of daily life, work, and play, and of communal life. A visual poet of the ordinary, the everyday, the things that make up the working life of the farms and towns of his native Nebraska, of the Midwest wherever he found it, Morris captured things and places that had almost passed away. We think of him as a photographer of the passing, of the life of dirt farmers in the Midwest, of small towns emptied of spirit and ambition. In his photographs of city streets, a similar air of gritty desolation clings to the fronts of row houses and stoops, telephone poles, fireplugs, run-down sidewalks. He seemed drawn to ruins, the worn-out, the time-ravaged. Elegy seems the defining mode of his pictures.

Although this impression of Morris's photographs—based on his subjects more than his technique, as if his pictures were clear glass windowpanes—seems indelible, it is in need of revision and qualification. His work looks like documentary photography in the mold of that of the 1930s. Similarities abound, but the identification is mistaken. Morris had other intentions, and although what an artist believes about his work is not always a

Through the Glass Curtain, The Home Place 1947 (detail, p. 114)

9

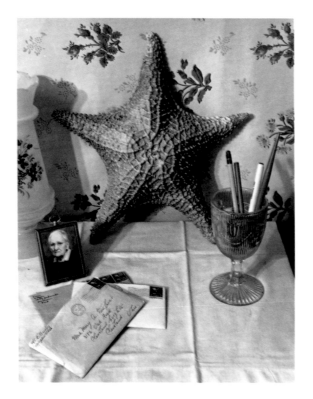

Starfish and Portrait, Cleveland, Ohio 1940s (p. 104)

reliable guide to what is actually there, how this artist understood his picture making, how he saw photography in relation to the fiction writing that was his major vocation, can guide us to a shrewder understanding of his images. Elegy, for example, is far from Morris's purpose, which is closer to a sacramental embrace of objects "salvaged," as he often said, from the ravages of time.

Morris began to photograph about the same time he began to write fiction, and for about fifteen years he thought deeply and innovatively about both mediums, how he might bring them together, how each might illuminate and enlarge the other. *Starfish and Portrait, Cleveland, Ohio* (1940s) distills his project into a kind of emblem or logo. A small framed portrait is placed on one side of a writing table covered with a cloth; opposite are pens and pencil in a stamped-glass goblet, and below are letters from elsewhere awaiting reading and answering, perhaps words from the relative in the framed photograph. And the glorious five-pointed starfish, a memento salvaged from a beach, leans against (and echoes) the floral-patterned wallpaper in such a way that its two bottom legs triangulate the pictured photograph and the writing tools. This corner in a modest home, recorded by the camera, reveals objects and an insight: writing and photography joined by the legs of the starfish, a third thing, something simple and inexpressibly elegant, its veined surface both catching and throwing

light, something already made over as metaphor, star and fish improbably imagined as one thing. Tightly focused, Morris's photograph gives the starfish a near-monumental scale. Standing between writing and image making, it hints at further possibilities of metaphor, the "third view" he refers to in a statement of 1940 that accompanied his first publication of texts and pictures together.

The tangible results of Morris's experiments appear in what he called "photo-texts," books with images and words adjoining each other in provocative ways, notably: *The Inhabitants* (1946), *The Home Place* (1948), and *God's Country and My People* (1968).[1] The first two books employ strikingly different principles of combination; the third reverts more or less to the method of the first volume. The subject-matter in all three books echoes that of Morris's fiction in the same years, drawn from personal memories of his childhood and youth in Nebraska and Chicago. If his writings verge toward autobiography (of a fictive sort), his photographs are more autobiographical still, for each picture tells where Morris was at a specific time and what he saw in that place. What he did with these data of actual experience, what he made of them in and next to his fiction, how he understood their own imaginative possibilities, are questions that point us toward the heart of an enthralling body of American photographs.

In a lovely, tender story called "Real Losses and Imaginary Gains" (1973), Morris's narrator (patently himself) recalls a visit "last summer" with his Aunt Winona. He has just learned that she has "passed away."

> My aunt's couch faced the door, which stood open, the view given a sepia tone by the rusted screen. At the bottom, where children sometimes leaned, it bulged forward to shape a small hole. The view framed by the door was narrow if seen from the couch. Lying there, my aunt took in only what was passing: she did not see what approached, or how it slipped away. On the steps of the bungalow across the street children often crouched, listening to summer. In the yard a knotted rope dangled a tire swing to where it had swept away the grass. A car passed, a stroller passed, music from somewhere hovered and passed, hours and days, weeks and months, spring to winter and back to spring, war and peace, affluence and depression, loved ones, old ones, good ones and bad ones, all passed away.[2]

I choose this passage almost at random. It is like so many scenes that recur throughout Morris's work: an enclosed place, an opening outward, a hole or crack or gap in a wall or window or door serving as an aperture to the outer

world, a breach through which the outer world forms itself into an image in the eye and mind and imagination of a character. Here the character is an old woman about to die, to "pass away" herself, and the author imagines what she sees, makes in words a permanent present of what she sees as *passing*. Real losses get transformed into imaginary gains.

Sometimes the character is a young boy very much like what Morris imagined himself to have been and what his memory served up as imagined experience.

> In the Platte Valley of Nebraska, street culverts, piano boxes, the seats of wagons and buggies, railroad trestles, low bridges, the dark caves under front porches were all favored places of concealment. With Br'er Fox I shared the instinct to lie low. Seated in dust as fine as talcum, my lap and hands overlaid with a pattern of shadows, I peered out at the world through the holes between the slats. As rain passed, a tethered cow mooed, a woman collected clothespins in the hammock of her apron, thunder crackled, rain puffed dust in the road, the bell tinkled on the Jewel's Tea Wagon as it crossed the tracks.[3]

The dying aunt "took in" the world framed by the narrow door, images only of what "passed." The boy "peered out," all eagerness to see and know everything. Just as old age and childhood are two sides of the same continuum, so taking in and peering out are variants, different yet much the same, of a continuous process of seeing.

The active eye, peering and taking in, introduces an abiding theme of Morris's fictions, what he most often speaks of in his narratives: what and how his characters see, how they connect (or not) with what is passing, how they make do in the field of time. It is a commonplace that the field of vision and the field of time are one, inseparable. That what we see is always passing is the stuff of countless clichés. But Morris raised this prosaic observation to the level of principle, a principle as rigorous and difficult in his actual photographs as in the craft of vision he employed in his fiction. As the passages already quoted reveal, he wrote photographically, and not just in the sense of highly specific verbal image making. The act itself of looking, often through apertures that resemble the lens of a camera, defines his characters' struggle to live within themselves among others, to live in the flux of time, with the present giving way to the future and the past clinging as memory.

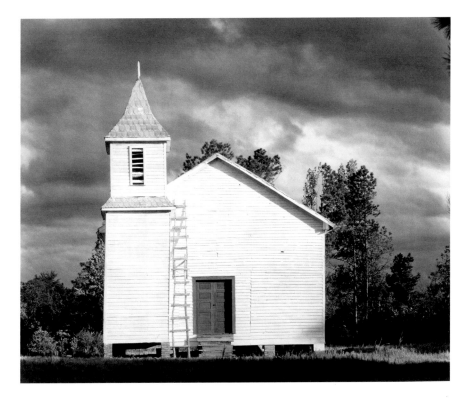

Walker Evans, *Rural Church with Adjacent Belltower and Ladder (Georgia or South Carolina)* 1936, gelatin silver print

* * *

Unique, and yet at first glance familiar: Morris's pictures, in their initial impression, their vernacular, time-scarred subject-matter, their laconic manner, seem to overlap especially with the work of Walker Evans. But first-glance affinities only underscore differences. Evans, about seven years older than Morris, also came to photography through literary experience, only it was blockage as a writer that seems to have drawn him to the camera. The nineteenth-century French writers Gustave Flaubert and Charles Baudelaire opened his eyes and filled him with the desire to capture immediate experience, experience mainly of the modern city, and photography became his means of fulfilling that desire. Evans continued to write—sketches, stories, lists of objects and impressions—and to read favorite authors such as Walt Whitman, Henry James, James Joyce, and Marcel Proust. It has been noted many times that Evans's pictures resonate with literary intentions. "I think I incorporated Flaubert's method," he told an interviewer, "almost unconsciously, but anyway I used it in two ways: both its realism, or naturalism, and his objectivity of treatment. The non-appearance of the author. The non-subjectivity. This is literally applicable to the way I want to use a camera and do."[16]

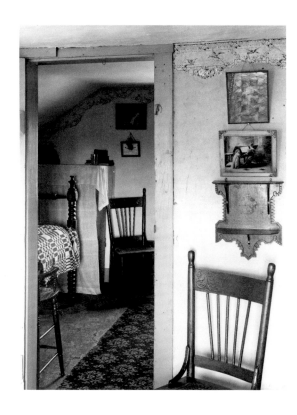

Walker Evans, *Bedroom and Hallway Interior, near Copake, New York* 1933, gelatin silver print

This resembles the way that Morris too used the camera: a frontal approach to the subject, a style apparently without style, a style of anonymity. We can imagine Evans's happy assent to these words by Morris: "In the anonymous photograph, the loss of the photographer often proves to be a gain. We see only the photograph. The existence of the visible world is affirmed, and that affirmation is sufficient. Refinement and emotion may prove to be present, mysteriously enhanced by the photographer's absence. We sense that it lies within the province of photography to make both a personal and an impersonal statement." Evans would have approved of the following sentiment as well: "There is a vein in my taste, we might call it classic, which seeks for an ordered, harmonious resolution of all pictorial elements. My frontal stance to the subject betrays this intention. I love the way the object stands there, ineluctably, irreducibly visible. The thing-in-itself has my respect and admiration. To let it speak for itself is a maximum form of speech."[17]

But agreement in principle is not equivalent to identity of purpose, nor does it result in the same kind of picture. "I am flattered to have my photographs compared to those of Evans," Morris wrote, "but this comparison is misleading." He took Evans's work as straightforward documentation, the work of a social commentator and historian who depicts the history of the present, how things now look and what that might reveal about society.

Wright Morris: An Appreciation

Ralph Lieberman

Wright Morris was unique. There have been greater writers and greater photographers—although many of his evocations of life on the plains are as powerful and moving as anything in American literature, and a number of his pictures are as fine as any ever made—but no one person has ever been as good at both fiction and photography.

Morris spent much of his artistic life considering the asymmetrical connections of fictional images to the imagination, and of photographic images to the real world. Many of his thoughts are gathered in *Time Pieces*, an anthology of articles and lectures published in 1989.[1] Subtitled *Photographs, Writing, and Memory*, the volume includes reflections on the interrelationships among these three things, which were Morris's chief concerns in a long literary and photographic career. But the subtitle does not mention other matters that were of great interest to him: the photograph as both subject and object, the nature of imagination, and the power of art to alter memory or displace experience. There are many elegant and pithy remarks in the essays in *Time Pieces*,[2] but to read through it in search of a pass key to either Morris's written or photographic work is frustrating, for he was not always consistent,[3] and he sometimes outgrew formulations that had once pleased him.[4]

As Morris practiced two interpretive-descriptive crafts at once, and published a number of books in which texts and images were combined, we might easily gain the impression that his words describe his pictures and his

Barber Shop, Weeping Water, Nebraska 1947 (detail, p. 97)

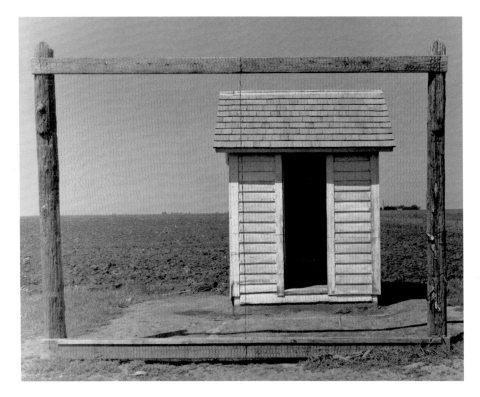

School Outhouse and Backstop, Nebraska 1947
(p. 87)

pictures illustrate his words. Yet Morris was quite insistent on the separation between the two modes, and we have his own words warning us to guard against easy interpretations:

> Through writing, through the effort to visualize, I became a photographer, and through my experience as a photographer I became more of a writer. This has been well remarked by my readers, but I would make one crucial distinction. What I see as a writer is on my mind's eye, not a photograph. Although a remarkable composite of impressions, the mind does not mirror a photographic likeness. To my knowledge I have never incorporated into my fiction details made available through photographs. This is a mite singular, but not paradoxical. The mind is its own place, the visible world is another, and visual and verbal images sustain the dialogue between them.[5]

If Morris says in this passage that he did not write from photographs, he does not say he never photographed the favorite subjects of his prose. Because we know that the world of his novels was centered on rural life in the great plains, we might tend to see an image such as *School Outhouse and Backstop* (1947) as a straightforward presentation

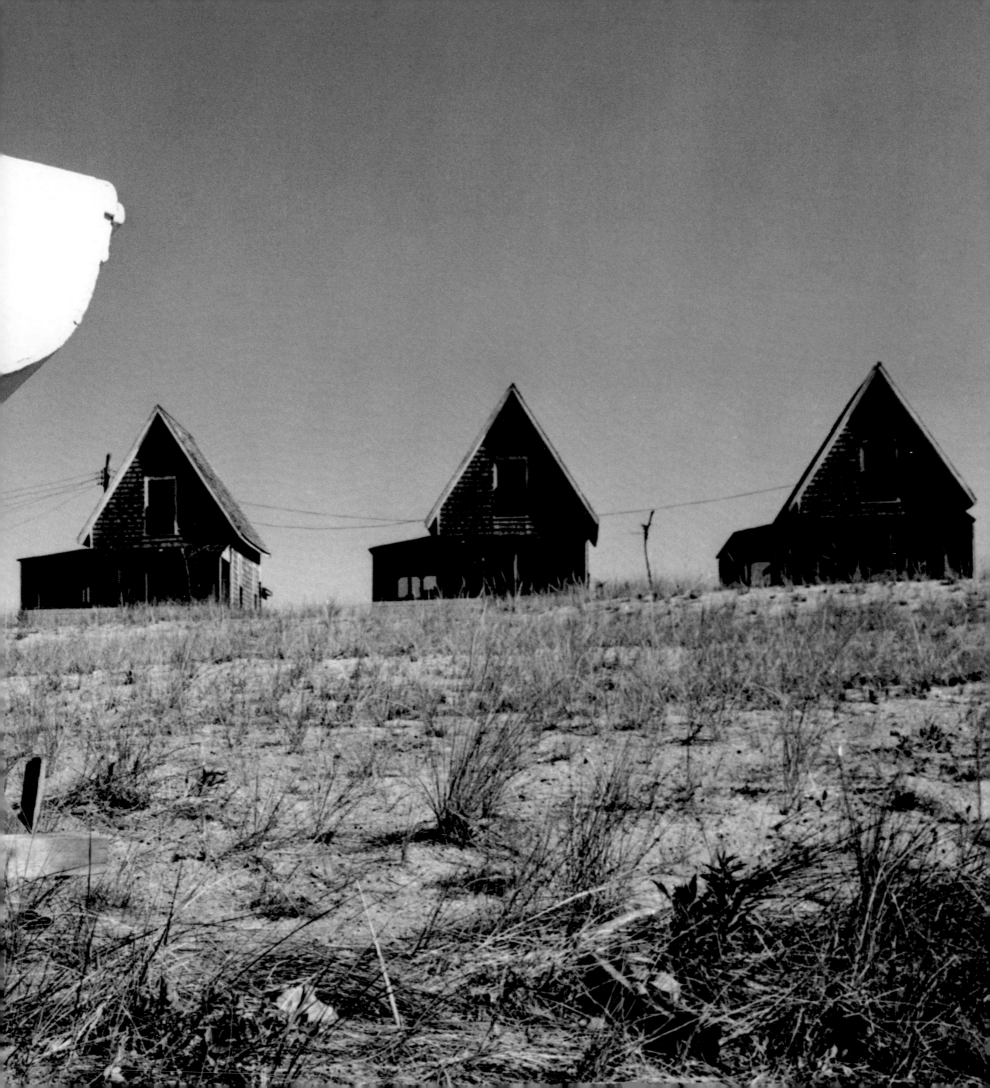

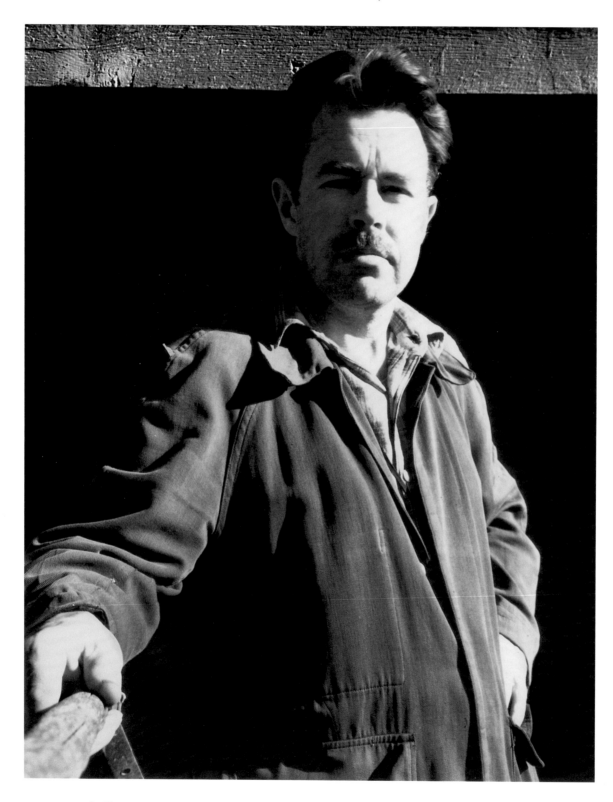

Self-Portrait at the Home Place 1947. Courtesy Mrs. Josephine Morris

The Photographs

The photographs belonging to The Capital Group Companies, Inc. and The Capital Group Foundation were printed by Wright Morris between 1979 and 1982; the date of the negative is given in the caption. The photographs are all gelatin silver prints measuring either 8 × 10 or 10 × 8 ins., except pls. 5, 33, 49, 53, 55, 59, 70, and 73, which are 11 × 14 or 14 × 11 ins. All photographs are © 1998 Josephine Morris.

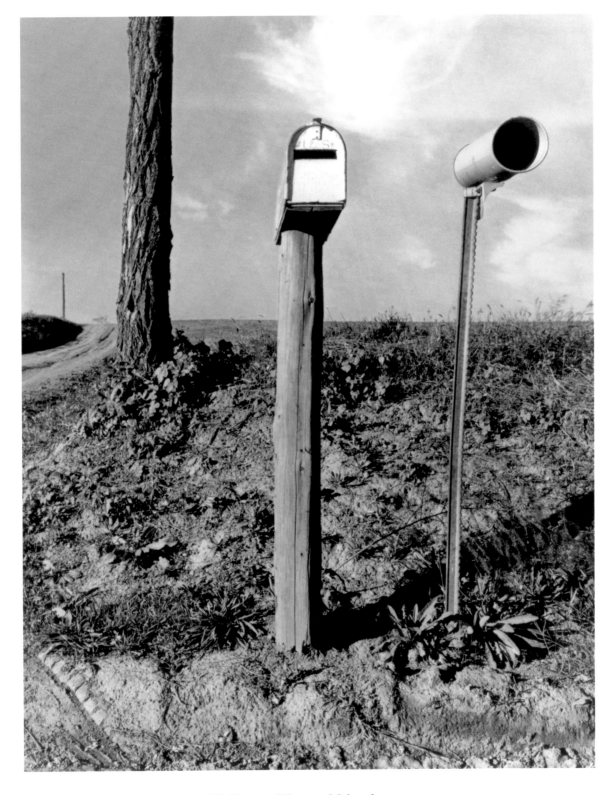

Mailboxes, Western Nebraska 1947

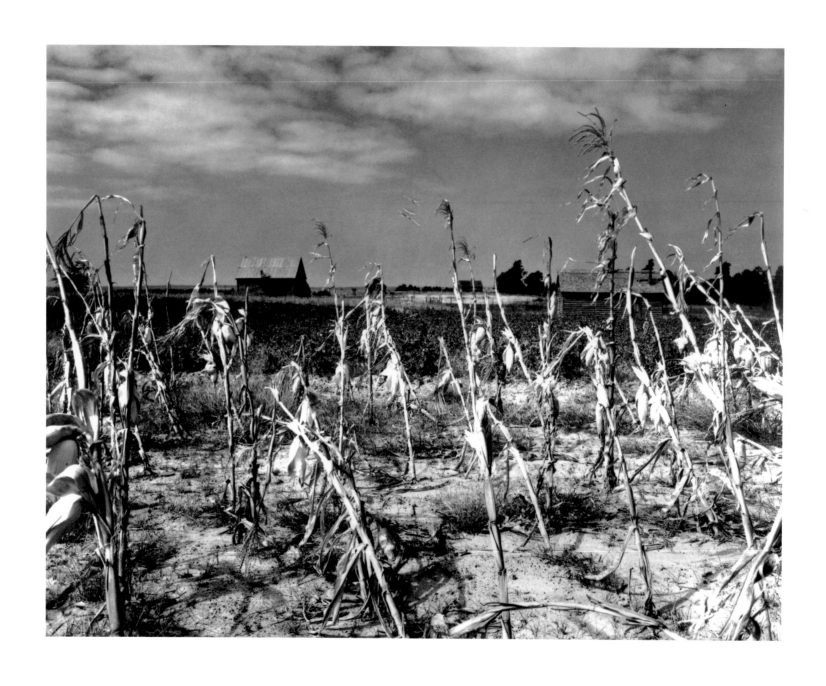

Cornfield, South Carolina 1940

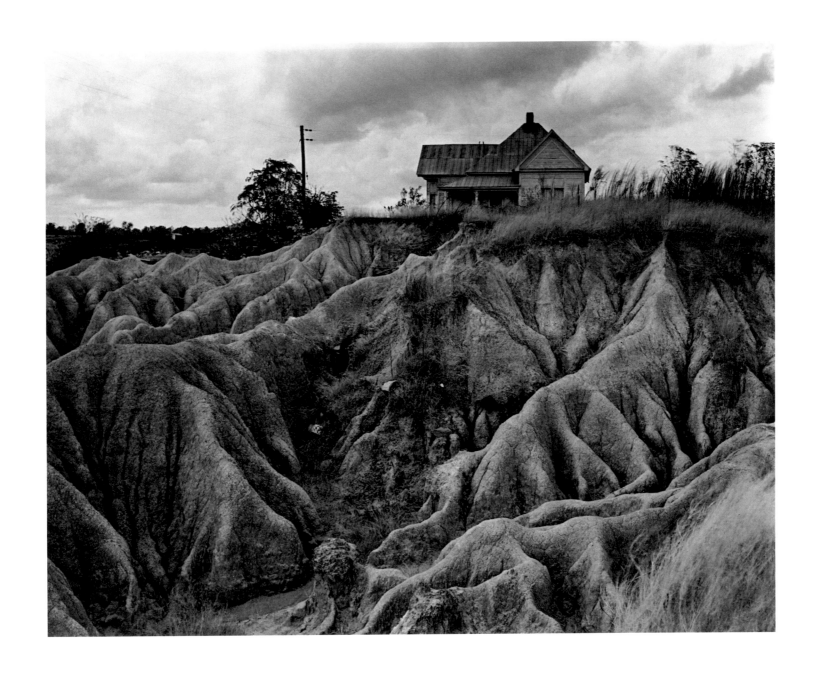

Faulkner Country, near Oxford, Mississippi 1940

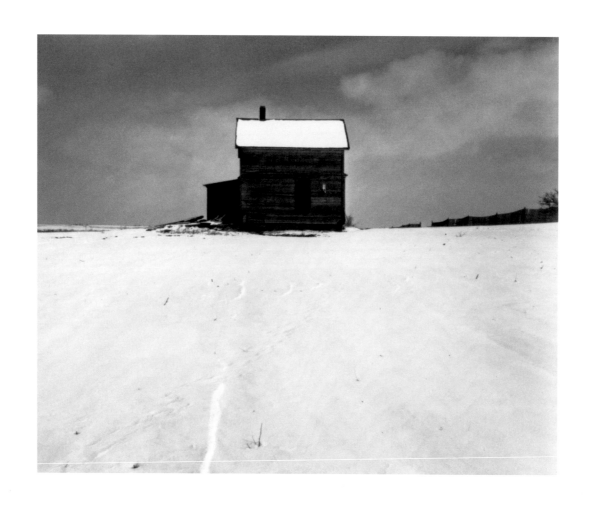

House in Winter, near Lincoln, Nebraska 1940

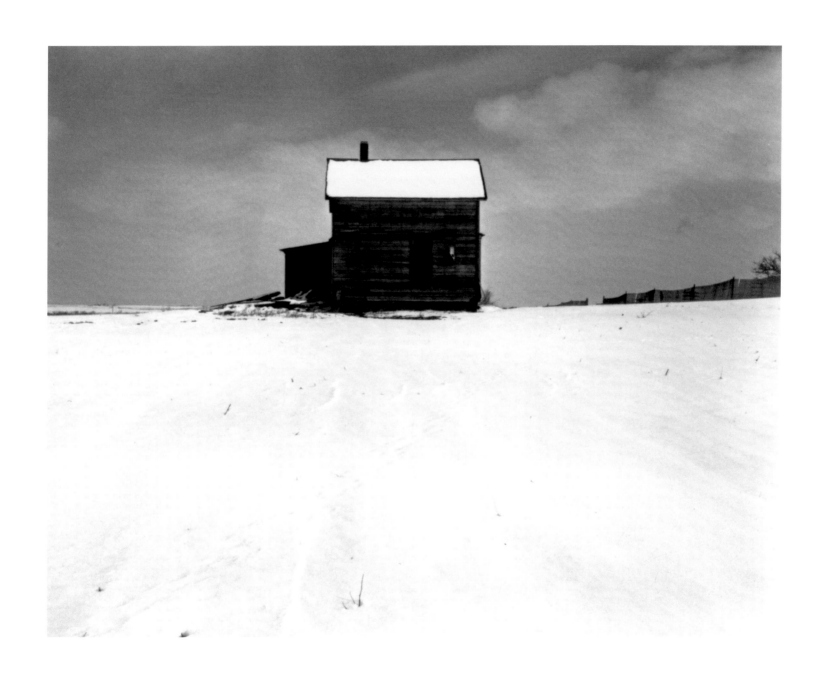

House in Winter, near Lincoln, Nebraska 1941

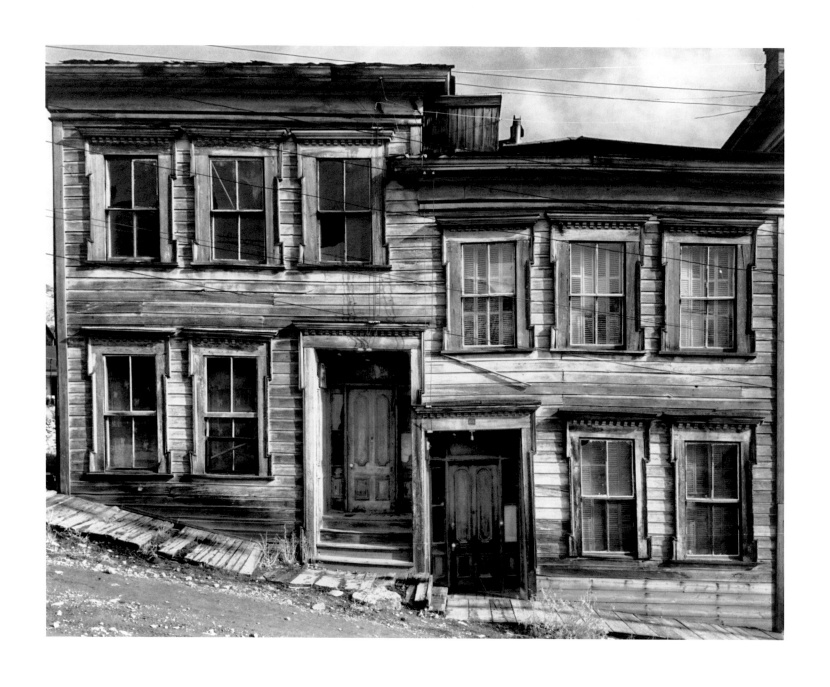

Houses on Incline, Virginia City, Nevada 1941

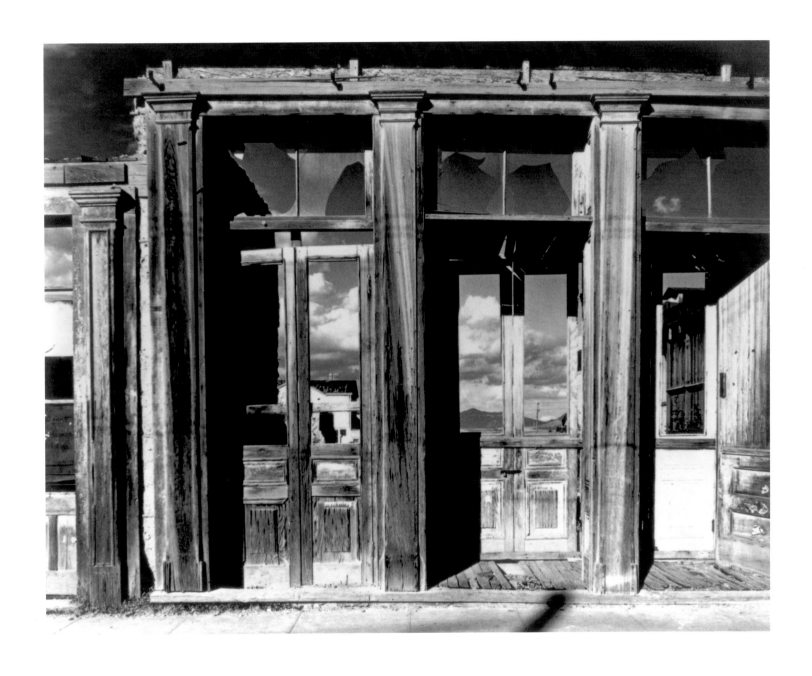

Tombstone, Arizona 1940

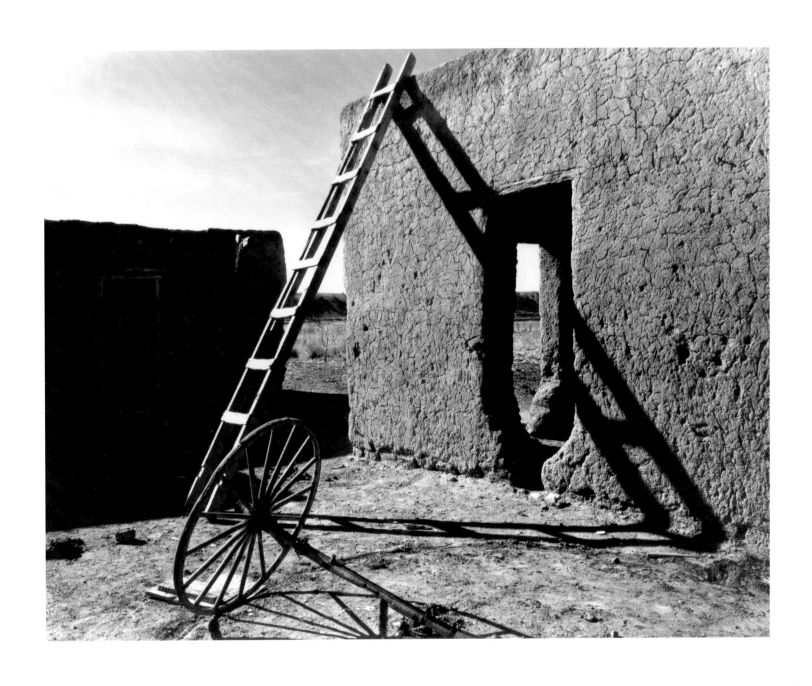

Wall, Wheel, and Ladder, New Mexico 1940

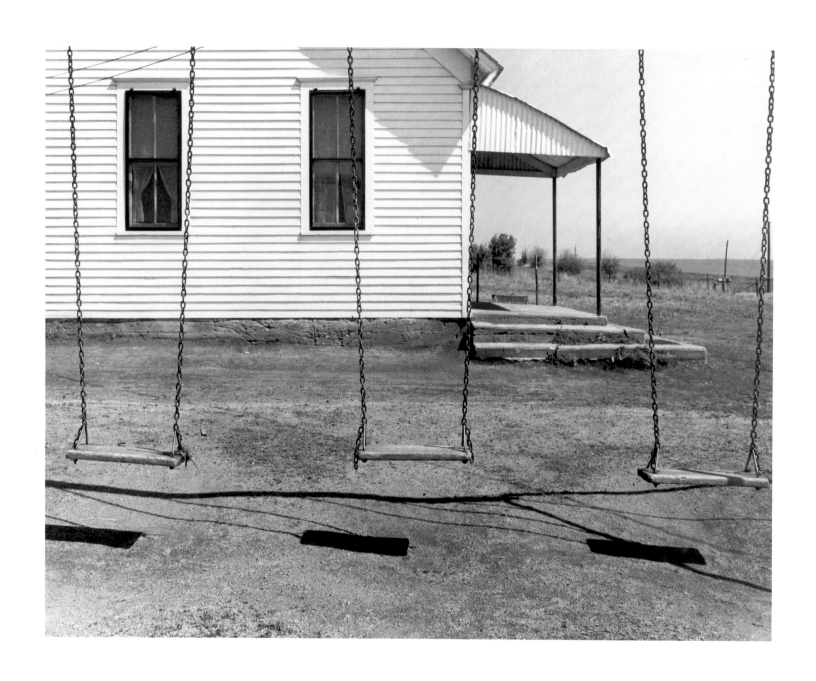

Schoolhouse with Swings, Nebraska 1947

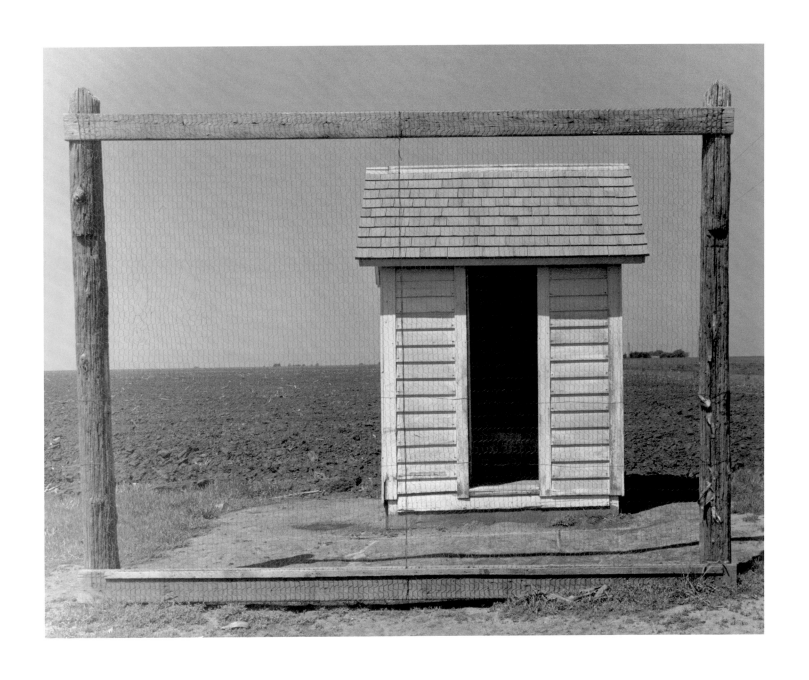

School Outhouse and Backstop, Nebraska 1947

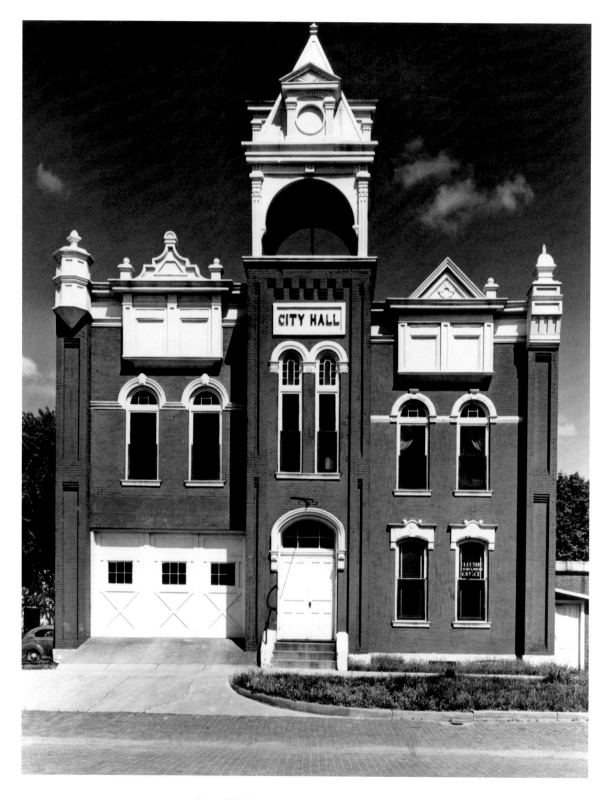

City Hall, Tecumsah, Nebraska 1947

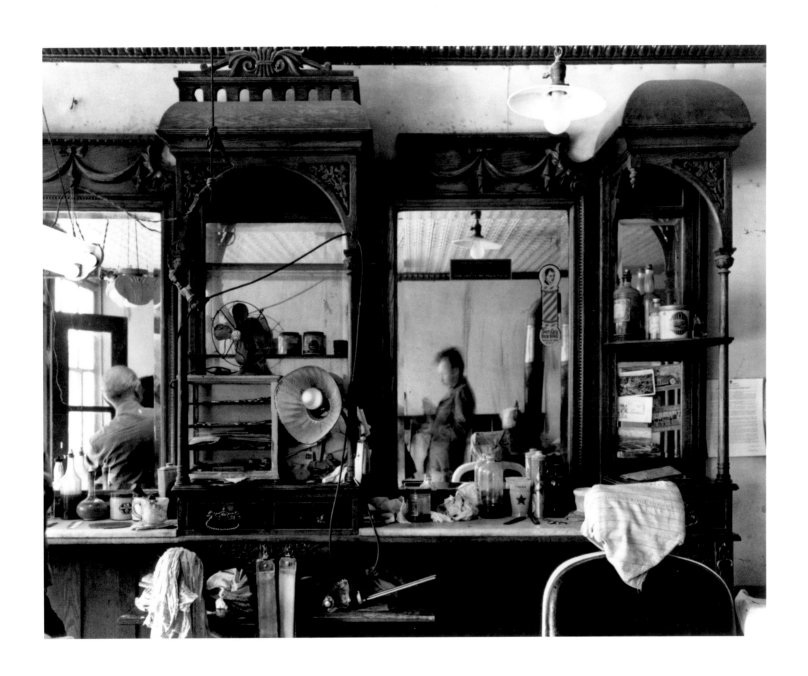

Barber Shop, Weeping Water, Nebraska 1947

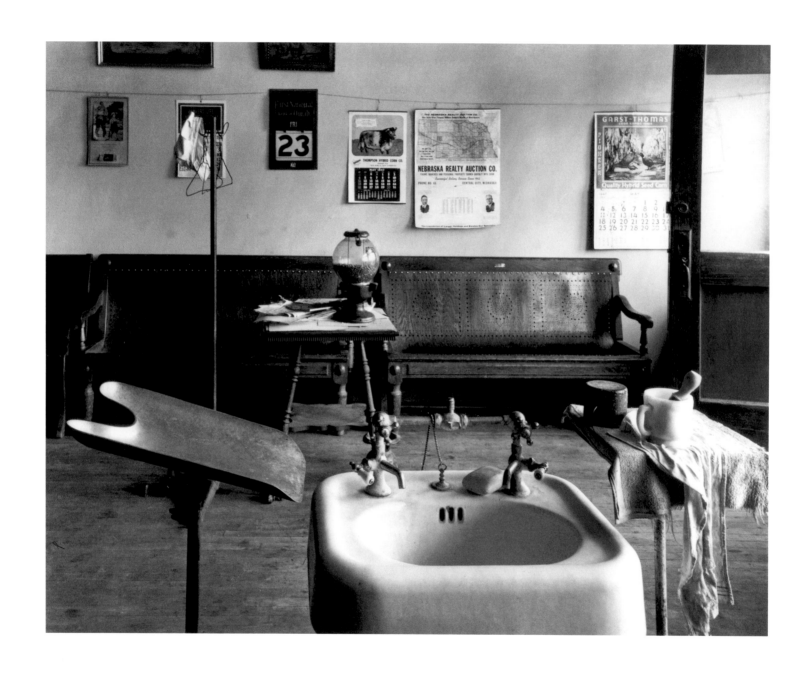

Barber Shop Interior, Cahow's Barber Shop 1947

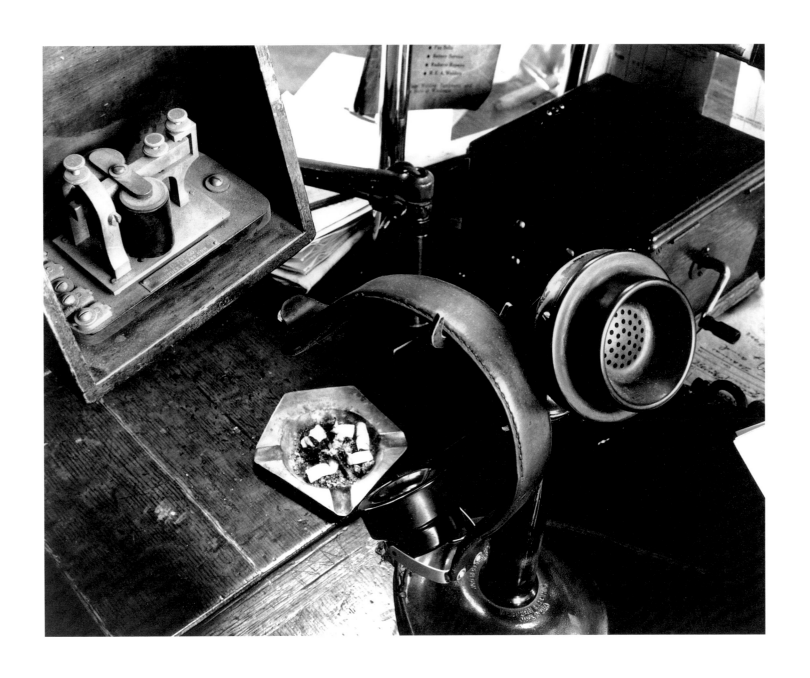

Desk in Train Depot 1947

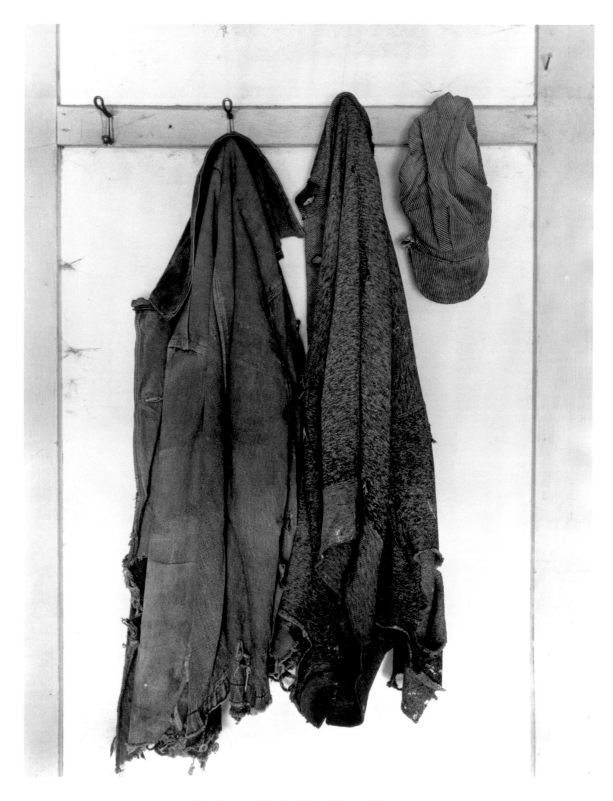

Clothes on Hooks, The Home Place 1947

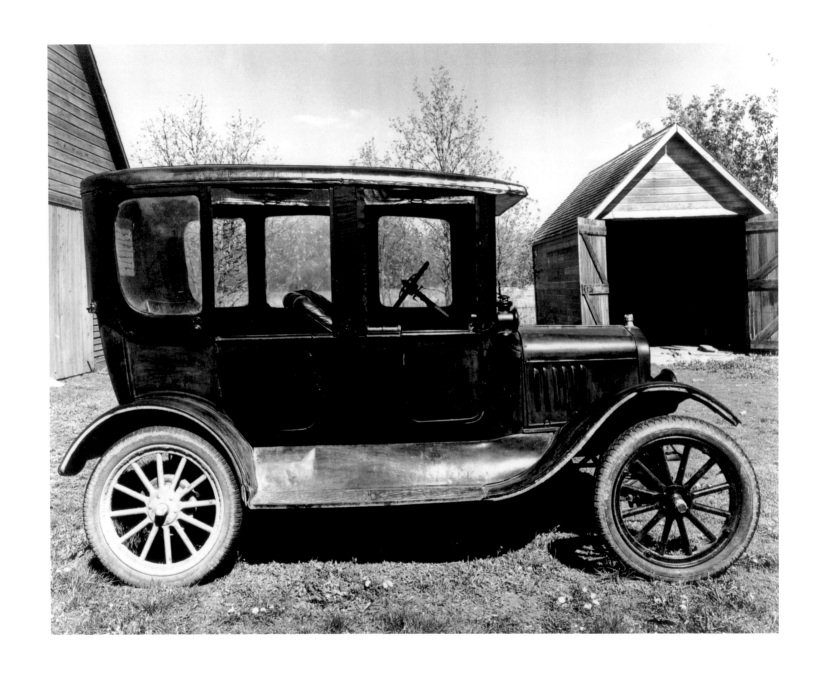

Model T, Ed's Place 1947

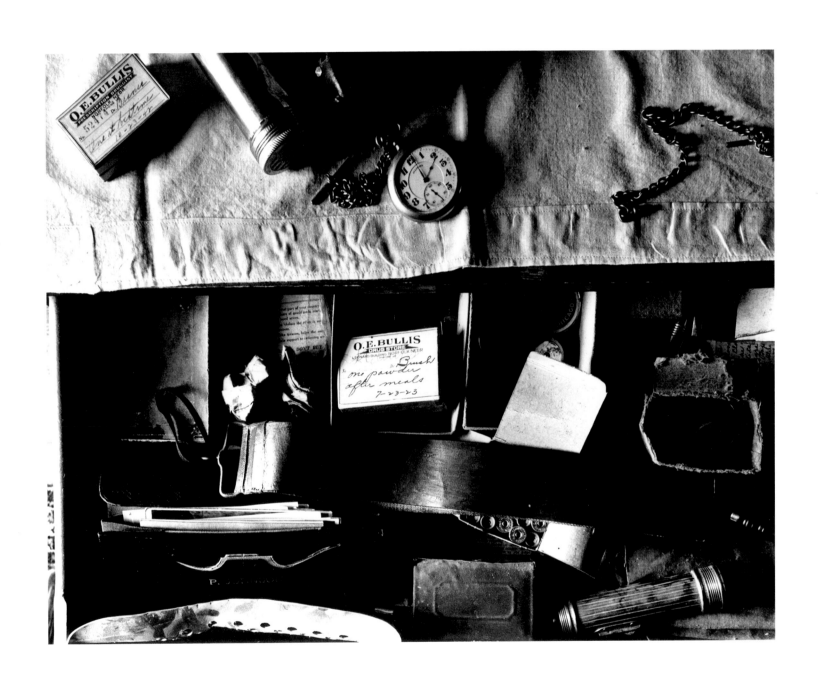

Dresser Drawer, Ed's Place, near Norfolk, Nebraska 1947

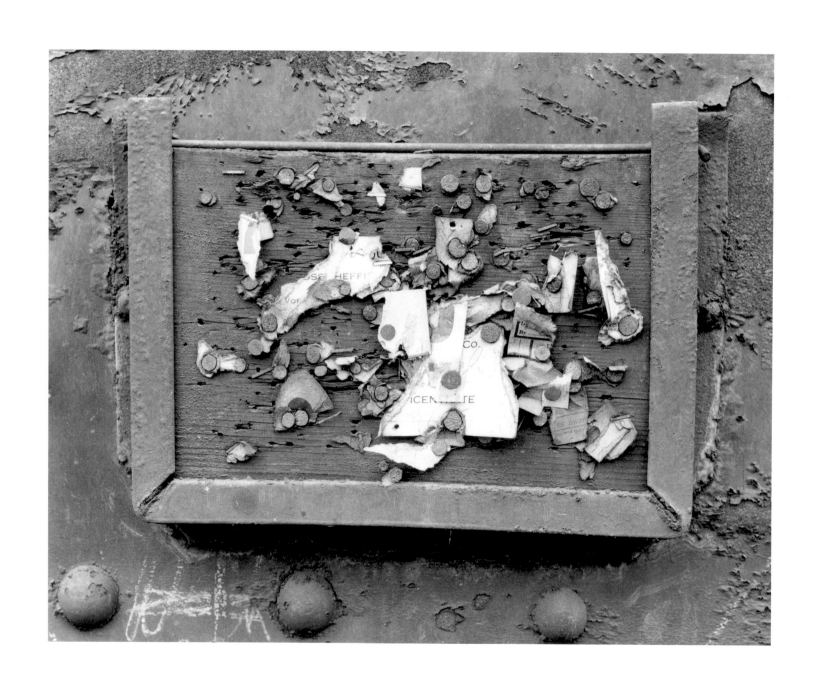

Bills of Lading on Freight Car 1947

Chronological Checklist